NICOTEXT

Bla Bla Sports

ISBN: 978-91-85449-26-2
Printed in Polen

Cover Design by Digital Artist Johan Andersson

www.nicotext.com

The average life span of a major league baseball is seven pitches.

Babe Ruth wore a cabbage leaf under his cap to keep him cool. He changed it every two innings.

The longest baseball game in major league history was on May 1, 1920 between The Boston Braves and The Brooklyn Robins. The game lasted 8 hours and 22 minutes, went 26 innings, and was finally called a draw with a score of 1-1. It finally had to end because there were no stadium lights.

It takes 3,000 cows to supply the NFL with enough leather for a year's supply of footballs.

Contrary to what you may have read as a "fact", golf balls can have up to 500 dimples. There is no "set" or required number. It varies with the design of the ball.

The term "home run" was used in the sport cricket before it made its way to baseball.

Golf was banned in England and Scotland in 1457 by King James II because he claimed it distracted people from the archery practice necessary for national defense.

Vasaloppet in Sweden is the oldest, biggest and longest cross-country ski race in the world. The race is 55.9 miles (90 km) long. Every year, 14,000 people compete in the race.

The best badminton shuttles are made from the feathers taken from the left wing of a goose.

Norway has won more gold medals at the Winter Olympic Games than any other country.

Field hockey is the national sport of Pakistan.

Before the year 1859 umpires sat in a rocking chair behind the catcher.

The first puck ever used in a professional hockey game was a frozen piece of cow dung.

American football originates from English rugby in the early part of 1800. The first football was round. American students played a similar game called ballown.

Babe Ruth hit 113 home runs in only two seasons.

About 42,000 tennis balls are used in the plus-minus 650 match-es in the Wimbledon Championship.

Lacrosse began as a sport played by Native Americans Indians in preparation for war.

In 1891, James Naismith, a physical education instructor, was thinking of new ways to provide exercise for the young men he was teaching. He nailed peach baskets onto the balconies at either end of a gymnasium and challenged his students to throw a soccer ball into them from below. Thus modern bas-ketball was born.

A badminton shuttle travels easily up to 112 mph (180 km/h).
It is one of the fastest objects in sports.

Fishing is the biggest participant sport in the world.

The Major League baseball teams use about 850,000 balls per
season.

A baseball has exactly 108 stitches. (A cricket ball has between 65 and 70 stitches.) Major League baseballs are covered with two figure-eight-shaped pieces of special cowhide that are sewn together by hand with 88 inches (223.5 cm) of waxed red thread using 108 stitches.

A soccer ball is made of 32 leather panels, held together by 642 stitches.

Basketball and rugby balls are made of synthetic materials. In earlier times, pigs' bladders were used as rugby balls.

Tiger Woods was eleven months old when he first started swinging a sawed off golf club in his garage.

Bank robber John Dillinger played professional baseball.

In 1963, baseball pitcher Gaylord Perry said:, "They'll put a man on the moon before I hit a home run.". On July 20, 1969, a few hours after Apollo 11 landed on the moon carrying Neil Armstrong, Gaylord Perry hit his first home run.

There are 122 pebbles per square inch on a Spalding basketball.

The Super Bowl is so popular that it is the number one at-home party event of the year.

Initially golf balls were made out of wood. Later they were made out of leather and were stuffed with feathers.

There are three golf balls sitting on the moon.

The chances of making two holes-in-one in a round of golf are one in 67 million.

In gangster slang, a fixed boxing match is called "a barney".

Canada beat Denmark 47-0 at the 1949 world hockey championships.

The five interlocking rings on the Olympic flag represent the five continents linked together in friendship.

Before soccer referees started using whistles in 1878, they used to rely on waving a handkerchief.

Soccer legend Pelé was named Edson Arantes do Nascimento at birth.

The Aztec and Mayan Indians of Mexico and Central America played a complicated kind of ball game not unlike lacrosse. The game, played in a large stadium and witnessed by thousands of spectators, went on for several hours. When the game was finished, the captain of the losing team was slaughtered before the onlookers, his body torn limb from limb, and pieces of his heart passed among the crowd for members of the audience to nibble.

A bowling pin only needs to tilt 7.5 degrees to fall down.

A hockey puck weighs 0.38 lb (0.17 kg).

Lionel Simmons, a Sacramento Kings NBA player had just been named player of the week during the 1990-91 season when he was forced to sit out a few games. The injury? Wrist tendonitis caused by excessive use of his Nintendo Game Boy.

Michael Jordan, who retired in January 1999 but returned to the league in 2001, has scored more points (5,987) in the playoffs than any other player.

In 1985, at the age of seventeen, Germany's Boris Becker won the first of his three Wimbledon tournaments.

The first Paralympic Games took place in Rome, a week after the end of the 1960 Summer Olympic Games, also held in Rome.

Over 90 percent of the world's soccer balls are made in Pakistan.

Brazil is the only nation to have played in every World Cup.

More than 40 million soccer balls are sold each year worldwide.

Fans of ONDA, the Spanish soccer team, are paid to attend games at the local stadium.

In the 2002 World Cup matches, Brazil's Ronaldo himself scored as many goals (five) as England's entire team.

No NFL team that plays its home games in a domed stadium has ever won the Super Bowl.

F. Scott Fitzgerald, the American novelist most famous for his works that chronicle the 1920's, was rejected from the Princeton football team because of his size. He was about 5'8" (1.77 m) and weighed about 135 lbs (61 kg) when he entered his freshman year.

The largest NFL stadium is the Pontiac Silverdome in Detroit, Michigan.

The huddle formation used by football teams today originated at Gallaudet University, a liberal arts college for deaf people in Washington, D.C.

The six most hazardous occupations in America are firefighter, racecar driver, astronaut, football player, police officer, and fisherman.

German chemists have made a replica of the World Cup soccer trophy that is the size of one molecule. That is less than 100-millionth the size of the original.

The first professional football team to sport an insignia on its helmets was the Los Angeles Rams in 1950. They hand painted yellow horns on their blue leather helmets.

On May 25, 1935, at the Big Ten Conference Championships, Jesse Owens (an American track and field athlete) broke three world records and tied a fourth, all in a span of 70 minutes.

In the 1950's the hula hoop was banned in Tokyo due to the large number of traffic accidents it caused.

Pro golfer Wayne Levi was the first PGA pro to win a tournament using a colored (orange) ball. He did it at the Hawaiian Open in 1982.

The only two people in the Baseball Hall of Fame that had nothing to do with baseball (i.e. they did not play, coach, own a team, etc.) are Abbott and Costello, the comedy duo.

Pittsburgh, Pennsylvania is the only city in the U.S. with three sports teams that all wear the same colors.

Max Baer once shouted out in the middle of a world title boxing fight: "Ma, he's killing me!".

The NBA (National Basketball Association) was formed in 1946 and the top-paid player that year was the Detroit Falcon's Tom King, who made $16,500. He managed this salary by not only playing for the team (salary $8,000 plus a $500 signing bonus) but also by convincing the team owner to hire him to be the publicity manager and business director for which he was paid an additional $8,000. Photos exist of King, still in his uniform with a typewriter on the bleachers, hammering out a press release after a game.

Until 1978, a player could legally use absolutely anything as a tennis racket.

St. Bernard is the patron saint of skiers.

The only bone not yet broken during any ski accident is one located in the inner ear.

The two quickest goals scored in the NHL were three seconds apart.

Dartboards are made out of horsehair.

When the University of Nebraska Cornhuskers play football at home, the stadium becomes the state's third largest city.

The pitches that Babe Ruth hit for his last-ever home run and that Joe DiMaggio hit for his first-ever home run where thrown by the same man.

Joe DiMaggio had more home runs than strikeouts during his career.

Olympic badminton rules say that the bird has to have exactly fourteen feathers. The International Badminton Federation rules say that the bird (shuttle) has to have exactly sixteen feathers that are uniformly between 24 inches (62 mm) and 27.5 inches (70 mm) long.

A game of pool is referred to as a "frame".

Racecar is a palindrome, which means a word or a sentence that is spelled the same way forward and backwards!

In the National Football League, the home team is required to provide 24 footballs for each game, although only 8-12 are normally used.

Cathy Rigby is the only woman to pose nude for Sports Illustrated (August 1972).

Since 1896, the beginning of the modern Olympics, only Greece and Australia have participated in every set-up of the Games.

Top English soccer club Liverpool was formed because its local enemy, Everton, couldn't pay the rent for their stadium. Therefore, Liverpool took over at the stadium (Anfield) and became one of England's top soccer team ever.

Lance Armstrong won his sixth Tour de France in 2004.

The NBA went on strike in 1998 to until 1999. The strike lasted for 191 days.

The record for the most Olympic medals ever won is held by Soviet gymnast Larissa Latynina. Competing in three Olympics, between 1956 and 1964, she won eighteen medals.

In 1975, Junko Tabei from Japan became the first woman to reach the top of Mount Everest.

Tenzing Norgay and Edmund Hillary were the first men to reach the summit of Mount Everest on May 29, 1953.

Why is a boxing ring square? The term "boxing ring" goes back to the bare-knuckle days of fighting. Spectators held a circle of rope around the fighters, but they were always crowding in on the action. Eventually, they used stakes to hold the ropes, which formed a square.

Most tennis injuries actually happen after the game when the winner tries to jump over the net.

Sometimes boxers apply live leeches to their black eyes. This sucks out the blood from the crushed tissue, evidently lessening the blackness and promoting healing.

Some unique research discovered that four out of every five boxers have sustained brain damage.

A spectator sport in Rome 2,300 years ago was called Cestus. Slaves were given gloves covered with spikes and told to fight each other. The winner's reward: life.

The best matadors in Peru used to be women.

Contrary to popular belief, the original Olympians did wear clothing. Then, one runner's loincloth fell off during a race in the year 720 BC. He kept right on going, and won the race handily. Like athletes of any era, the losers copied the techniques of the winner and subsequent competitions were held without clothes.

A Russian ballet dancer named Vaslav Nijinsky could jump into the air and cross and uncross his legs ten times before landing. No one has been able to duplicate this feat.

With one pitch, Babe Ruth could throw two balls simultaneously, and they would stay parallel all the way to the catcher.

A research study found that out of forty typical umpires tested, twelve needed new glasses.

Baseball players have the longest lives out of all occupations.

When you hit a baseball really hard, it momentarily changes shape by as much as 25 percent.

A perfect game in baseball is one in which the same player pitches the entire game without allowing any player of the opposing team to reach first base – by any means.

At Jack Russell Stadium in Clearwater, Florida, on June 26, 1985, organist Wilbur Snapp played "Three Blind Mice" following a call by umpire Keith O'Connor. The umpire was not amused, and saw to it that Mr. Snapp was ejected from the game.

Golfers use an estimated $800 million worth of golf balls annually.

In 1905, 18 men died from injuries sustained on the football field. President Theodore Roosevelt stepped in and instituted safety measures to make the game safer.

In 1970, 127 runners ran the NY Marathon. In 1998, that number had grown to 32,000. By 2006, more than 93,000 people world-wide applied to run.

Poland's Stella Walsh (Stanislawa Walasiewicz) won the women's 100-meter race at the 1932 Olympics in L.A., becoming the first woman to break the 12-second barrier. When she was killed in 1980 as an innocent victim in a robbery attempt, an autopsy declared her to be a male.

The first NBA player to score 38,000 points was Kareem Abdul-Jabar in 1989.

The largest baseball card collection, 200,000 cards, is in the Metropolitan Museum of Art.

The modern Olympic Games were first held in 1896 in Athens and were then followed in 1900 with the Paris Olympic Games. The winter Games were added in 1924.

No network footage exists of Super Bowl I. It was taped over, supposedly for a soap opera.

Super Bowl Sunday is the second-largest U.S. food consump-
tion day, followed by Thanksgiving.

The first woman to ride in the Kentucky Derby was Diane
Crump on May 2, 1970.

A 27-inch-high (68.5 cm) silver America's Cup holds no liquid –
it's bottomless.

A cowboy in a rodeo bull riding competition must hang on for eight seconds. The same applies to bareback bronco and saddle bronco events.

About 30 percent of the NBA players sport tattoos, compared with about 4 percent of the nation's population.

According to manufacturer Spalding, the average lifespan of an NBA basketball is 10,000 bounces.

According to the Detroit Free Press, 68 percent of professional hockey players have lost at least one tooth.

According to the official rules of baseball, no umpire may be replaced during a game unless he is injured or becomes ill.

After his infamous 1997 ear-biting attack on Evander Holyfield, the Hollywood Wax Museum moved boxer Mike Tyson's figure to the Chamber of Horrors – next to the figure of Dr. Hannibal Lecter (from the movie "The Silence of the Lambs").

Akebono, the superstar sumo wrestler from Hawaii, weighs 516 pounds (234 kg).

Basketball is the most popular sport among college women, followed by volleyball and tennis.

In golf, a "Dolly Parton" is a putt on an especially hilly green. It's also known as a "roller coaster".

In golf, a "snowman" is a score of 8 for a hole or 88 for a round.

In hockey, a "butterfly" is a goaltending style in which the goalie keeps his knees together and feet slightly apart.

In hockey, the penalty box is often referred to as the "sin bin".

In July 1934, Babe Ruth paid a fan $20 for the return of the baseball he hit for his 700th career home run.

The Harlem Globetrotters once played before an audience of one – in 1931, before Pope Pius XI.

In speed skating, competitors wear colored armbands to indicate their starting lanes. White is worn by the skater starting in the inner lane, red by the skater starting in the outer lane. The skaters change lanes after each circuit of the track.

In the 1979-80 season, at age 19, Wayne Gretzky became the youngest hockey player ever to score fifty or more goals and a hundred or more points in a season, and the youngest player to be voted "Most Valuable Player".

In the first Boston Marathon, 15 runners competed.
10 of them finished the race.

In the opening procession of the Olympics, the team representing the host nation always marches last.

The name of the game "cricket" is believed to have been derived in the late 1500's from the old French word "criquet", meaning "goalpost".

The official state sport of Alaska is dog mushing.

The oldest individual to win a medal in the Olympics was Oscar Swahn. He won a silver medal in shooting for Sweden in 1920. He was 72 years old at the time.

Five baseball gloves can be made from one cow.

Four players compete on an equestrian polo team.
Seven compete on a water polo team.

Gertrude Ederle was still a teenager when she became the first woman to swim the English Channel on August 6, 1926. Not only did she swim the channel, she also broke the speed record held by a man.

Major league baseball bats are made of ash.

No high jumper has ever been able to stay off the ground for more than one second.

Olympic testing of athletes for anabolic steroids began in 1976.

To a competitive swimmer, "d.p.s." means distance per stroke.

Ronald Reagan's favorite pastime sport was horseback riding.

Saint Lydwina is the patron saint of ice-skating.

7,000 years ago, the ancient Egyptians bowled on alleys not unlike our own.

Table tennis was originally played with balls made from champagne corks and paddles made from cigar-box lids. The sport was created in the 1880's by James Gibb, a British engineer who wanted an invigorating game he could play indoors when it was raining. Named "gossima", the game was first marketed with celluloid balls, which replaced Gibb's corks. After the equipment manufacturer renamed the game "ping-pong" in 1901, it became a hot seller.

Wrestler Hulk Hogan's real name is Terrence Gene Bollea.

The Brooklyn Dodgers (who later became the Los Angeles Dodgers) did not get their name because of their sporting ability. The term "dodger" was a shortened form of "trolley dodgers", which was first used to describe Brooklynites for their ability to avoid being hit by trolley cars.

The California Academy of Tauromaquia in San Diego is a world-renowned school for matadors.

The concealed-lace basketball was introduced in 1927. Before the concealed lace, the ball bounced at unexpected angles when the lacing hit the floor.

The first baseball game to be televised was not in the United States. It was in Tokyo, Japan.

The Chicago Tribune purchased the Chicago Cubs base-ball team from the P.K. Wrigley Chewing Gum Company for $20.5 million in 1981. The sale ended the longest continuous ownership of a team that stayed in its original city, which had been sixty years.

Kresimir Cosic is the only non-American player in the NBA Hall of Fame.

Four men in the history of boxing have been knocked out in the first eleven seconds of the first round.

Prior to 1900, boxing prizefights lasted up to 100 rounds.

In 1969 a brief battle broke out between Honduras and El Salvador. Although tensions had been rough between the two countries for some while, the reason for the war was El Salvador's victory over Honduras in the World Cup Soccer playoffs. Gunfire was exchanged for about 30 minutes before reason could prevail.

The team from Bulgaria was the only soccer team in the 1994 World Cup in which all eleven players' last names ended with the letters "ov".

Australian Rules football was originally designed to give cricketers something to play during the off-season.

Baseball cards have been around since 1886. Modern cards, with high-resolution color photographs on the front and player statistics on the back, date from 1953. The photos are taken in the spring, with and without team caps, just in case the player is traded to another team.

Racehorses have been known to wear out new shoes in one race.

Many Japanese golfers carry "hole-in-one" insurance, because it is traditional in Japan to share one's good luck by sending gifts to all your friends when you get an "ace". The price for what the Japanese call an "albatross" can often reach $10,000.

At 101, Larry Lewis ran the 100-yard (91,4 m) dash in 17.8 seconds setting a new world record for runners 100 years old or older.

The National Hockey League has a rule that prohibits their players from taking aspirin. Strangely, there is no rule that says they can't drink or use illegal drugs.

In the NHL in the 1960's, the league decided that home teams would wear white, while visiting teams would wear their dark jerseys. The reasoning behind this was that it would be more difficult to keep white uniforms clean while on the road.

Rudyard Kipling, living in Vermont in the 1890's invented the game of snow golf. He would paint his golf balls red so that they could be located in the snow.

When a male skier falls down, he tends to fall on his face. A woman skier tends to fall on her back.

The red capes used to taunt bulls in bullfights are the same shade of red as the bull's blood. That way you can't tell if it's covered with the bull's blood by the end of the fight. The spectators like bullfighting, but not the blood.

Men are a lot more streamlined than women for swimming, because the woman's breasts create a lot of drag. Enough, in fact, that racing suits have been developed with tiny pegs above the breasts to cause disturbance, which decreases the drag.

Golfings great Ben Hogan's famous reply when asked how to improve one's game was: "Hit the ball closer to the hole"

The youngest American female to score a hole-in-one (ace) was Shirley Kunde. It happened in August 1943 when she was thirteen years old.

The Tom Thumb golf course was the first miniature golf course in the United States. It was built in 1929 in Chattanooga, Tennessee by John Garnet Carter.

The Chinese Nationalist Golf Association claims the game is of Chinese origin (ch'ui wan – the ball hitting game) beginning sometime in the third or second 2nd century BC.

The youngest golfer recorded to have shot a hole-in-one is Coby Orr (five years old) from of Littleton.

Tokyo has the world's biggest bowling alley.

Six bulls are killed in a formal bullfight.

In 1870, British boxing champ Jim Mace and American boxer Joe Coburn fought for 3 hours and 48 minutes without landing one punch.

The national sport of Nauru, a small Pacific island, is lassoing flying birds.

JFK's golf clubs were sold for $772,500 at an auction in 1996. The buyer was Arnold Schwarzenegger.

"Vaimonkanto" or "Wife Carrying" is a sporting event. The "Carry an Old Gel" championship games are held annually in Sonkajarvi, Finland.

In the United States, more Frisbee discs are sold each year than baseballs, basketballs, and footballs combined.

A squash ball moving at 93 mph (150 km/h) has the same impact as a 0.22 inch (0.56 cm) bullet.

Approximately one out of four injuries by athletes involves the wrist and hand.

Ellen Macarthur, yachtswoman, had a total of 891 naps in 94 days that were each 36 minutes long while on her Vendee Round the Globe yacht race.

In the 1930's, American track star Jesse Owens used to race against horses and dogs to earn a living.

Karate actually originated in India, but was developed further in China.

Kite flying is a professional sport in Thailand.

Morihei Ueshiba, founder of Aikido, once pinned an opponent using only a single finger.

On average, it is estimated that females injure themselves ten times more than males do while playing sports.

The 1912 Greco-Roman wrestling match in Stockholm between Finn Alfred Asikainen and Russian Martin Klein lasted more than eleven hours. Klein eventually won but was too exhausted to participate in the championship match so he settled for the silver.

Billiards great Henry Lewis once sank forty-six balls in a row.

Boxing champion Gene Tunney taught Shakespeare at Yale University.

Horseracing is one of the most dangerous sports. Between two and three jockeys are killed each year.

There are nearly 32,000 golf courses in the world – over half of them in the U.S.

The last Olympic gold medals that were made entirely out of gold were awarded in 1912.

Because of World War I and World War II, there were no Olympic Games in 1916, 1940, or 1944.

At the 1904 Olympics in St. Louis, Fred Lorz, the apparent winner of the marathon, was disqualified when he admitted that after suffering from cramps early in the race, he hopped into an official's car at the nine-mile (14.5 km) mark and rode the next eleven miles (17.7 km) of the race. He said he decided to run into the stadium and break the winner's tape as a joke. Olympic officials were not amused.

Climbing ropes are able to hold over 6,000 pounds (2,722 kg).

Snowboarding was invented in the 1960's in Austria.

More than 100 million people hold hunting licenses.

Jean Genevieve Garnerin was the first female parachutist, jumping from a hot air balloon in 1799.

The high jump method of jumping headfirst and landing on the back is called the "Fosbury Flop".

Korfball is the only sport played with mixed teams, consisting of four men and four women.

Originally cheerleaders were all men. It was not until the 1920's that women became involved.

The hammer throw is illegal as a high school sport in all states except Rhode Island.

You will be charged with a fine if you spit on the tennis courts at Wimbledon.

Dimples on a golf ball reduce drag by creating turbulence as the ball flies through the air.

Many European-born hockey players and NHL stars play floor ball to enhance their skills.

In hockey, the term "top shelf" means a goal that enters the net in either one of the top corners and a "duster" is one who is on the team but never plays.

The modern water polo game originated as a form of rugby football played in rivers and lakes in England and Scotland with a ball constructed of Indian rubber. This "water rugby" came to be called "water polo" based on the English pronunciation of the Balti word for ball, pulu.

The modern high jump bar is made of glass-reinforced plastic or aluminum. Other materials are allowed, but there are weight and sag restrictions.

Stefan Holm from Sweden, at 5'9" tall (1.81 m), equaled American Franklin Jacobs' height-over-head record of 23,2 inches (59 cm) when he cleared 7'9" (2.40 m) to win the European Indoor Championships in March 2005.

Badminton: Men's doubles player Fu Haifeng of China set the official world smash record of 206 mph (332 km/h) on June 3, 2005 in the Sudirman Cup.

When Australian rugby league player Jamie Ainscough complained of an infection in his arm, doctors did an X-ray, which revealed that Ainscough Jamie had another player's tooth embedded into his arm. The tooth found its way into Ainscough's arm in a game nearly a month earlier but he wasn't sure how it happened. He said he planned to mail the tooth back to the other player.

While John Daly was playing golf at the Dutch Open in July, 2002, a piece of glass which was embedded in his hand worked its way out, causing Daly"s John's hand to begin seriously bleeding. Instead of going to a doctor to get stitches Daly squirted superglue on his hand to seal the wound. "I don't care if it's unwise medically", Daly said, "I'm not going to watch it bleed".

In 1996, Florida Panthers' winger, Scott Mellanby, was getting ready for a game when a large rat ran through the dressing room. Mellanby Scott jabbed the rat with his hockey stick and killed it – then scored two goals in the game. After that, Florida Panthers' fans started throwing rats (plastic, not live) on the ice whenever the team scored a big goal. During the team's run to the Stanley Cup finals, the ice would be completely covered with rats every time Florida scored. Opposition goalies had to hide in the net to prevent themselves from getting hit with rats. The NHL banned the tradition after the 1996 season because games were being delayed for so long.

In an open doubles hacky sack competition, Tricia George and Gary Lautt hold the world record of 132,011 consecutive kicks in 20 hours and 34 minutes without a miss or foul.

By the time Shaquille O'Neal was thirteen years old, he was already 6'6" (2 m). He currently wears an amazing size 22 (21 ½) shoe.

No British male has won Wimbledon since 1936 (Fred Perry was the last), and no British woman has won since Virginia Wade (1977).

The bowling ball was invented in 1862.

The highest recorded bowling score short of 300 was 299 1/2! In 1905 a bowler threw his last ball in what would have been a perfect game. One of the pins split in half; one part fell over and the other remained standing.

There are more sesame seeds on a Big Mac than there are dimples on a golf ball!

The only logo not allowed on a major league baseball uniform is a baseball.

The candy bar, Baby Ruth, is named after the daughter of President Cleveland, not Babe Ruth, the baseball player, as most think.

$10,000 was the fine issued to Charles Barkley by the NBA for accidentally spitting on an eight-year-old girl. $7,500 was the size of the fine issued by the French Open to John McEnroe for swearing during his loss in the tournament's first round.

The youngest person ever to have won a world boxing championship is Wilfred Benitez. The year was 1976 and he was only seventeen years old.

Gatorade was named after The University of Florida Gators where it was first developed.

The word rodeo is from the Spanish rodear meaning "to surround" or "go around".

An early version of Darts called "Puff and Dart" used a blow-pipe to fire a dart at a target.

The numbers on a dartboard are arranged to minimize the possibility of high scores from lucky throws by placing small numbers on either side of larger ones.

A dentist, William Semple, invented chewing gum to exercise his jaws.

Richard Presley spent 69 days and 19 minutes in an underwater module in a lagoon off Key Largo, Florida, in 1992, setting the record for the longest deep dive. His endurance test was carried out as part of Project Atlantis, which aimed to explore human tolerance to life in an underwater environment.

The deepest dive record using scuba gear is held by Jim Bowden of the United States. In 1994, he dived to a depth of 1,000 feet (305 m) in the freshwater Zacatoa Cave in Mexico.

It is a long-standing tradition in the United States (though not universally observed) that high school football games are played on Friday, college games on Saturday, and professional games on Sunday. However, in recent years, weekday-night games have become more common.

In American football, "a punt" is a kick in which a player drops the ball and kicks it before it hits the ground.

A fantasy sport is a game where fantasy owners build a team that competes against other fantasy owners based on the statistics generated by individual players or teams of a professional sport. It's estimated by the Fantasy Sports Trade Association that 16 million adults in the U.S., age 18 to 55, play fantasy sports. Fantasy sports are also popular throughout the world with leagues for soccer, cricket and other non-U.S. based sports.

The world's oldest soccer competition is the FA Cup, which was founded by C. W. Alcock and has been played by English teams since 1872. The first official international soccer match took place in Glasgow in 1872 between Scotland and England in Glasgow, again at the instigation of C. W. Alcock.

A very large number of people play soccer at an amateur level. According to a survey conducted by FIFA and published in the spring of 2001, over 240 million people regularly play soccer in more than 200 countries in every part of the world.

Physiologists claim that rowing a 1.25 miles (2,000 m) race is equal to playing back-to-back basketball games.

Baron Pierre de Coubertin, founder of the modern Olympics, was a rower.

Did you ever wonder why the official distance of a marathon is exactly 26 miles, and 385 yards (42.2 km)? In 1908, the marathon standard had been set at exactly 26 miles (41.84 km). However, at the Olympic marathon in London, it was decided that the royal family needed a better view of the finish line so organizers added an extra 385 yards (0,35 km) to the race so the finish line would be in front of the royal box. And it's been that way ever since.

Danish rider Lis Hartel won the silver medal in the 1952 equestrian dressage event in Helsinki. Hartel suffered from an inflammation of the spinal cord known as poliomyelitis, which required her to be lifted on and off her horse each time.

And you thought they just used a match. Did you know that traditionally the Olympic flame in Olympia, Greece is rekindled every two years using the sun's rays and a concave reflective mirror?

Before there was gymnast Kerri Strug, there was Japan's Shun Fujimoto. In the men's team gymnastics competition in 1976, he actually broke his kneecap while performing in the floor exercise. The following day, however, he needed a top-notch performance in the rings for Japan to secure the gold. With no painkillers, he performed a near flawless routine and stuck the landing, putting a tremendous amount of pressure on his injured knee. He grimaced in pain as he held his position for the judges, and then finally collapsed in agony. Japan won the team gold by just four tenths of a point over the Soviet Union.

In 1928, reportedly six of the eight entrants in the women's 800-meter race collapsed at the finish line in an "exhausted state". Poor training methods and the brutal Amsterdam sun were the two major causes of distress. That event was subsequently cancelled until 1960.

Only two countries south of the equator have ever won medals at the Olympic Winter Games – Australia and New Zealand.

Before 1976, no male or female had ever received a perfect score in any Olympic gymnastics event. And then came Nadia Comaneci, all 4-foot-11 inches (1.5 m) and 86 pounds (39 kg) of her. The 14-year-old Romanian dazzled the judges in Montreal to the point where they couldn't help but give her a perfect 10. And they didn't stop there, for not only did Comaneci receive the first perfect score, she then proceeded to get six more!

The tropical island had never had a representative at the Winter Olympics before the Jamaican bobsled team made its Olympic debut in 1988 at Calgary. They finished in last place that year, but have been entering ever since. In Lillehammer 1994 they even finished in 14th place, ahead of both sleds from the United States.

Men's gold medal favorite Yevgeny Plushenko is the first and only skater in history to successfully land a quad-triple-triple jump combination in competition.

The oldest man to receive a Winter Olympics medal was 83-year-old Anders Haugen. The Norwegian-American actually received his ski jump bronze medal 50 years after he competed in 1924 when a scoring error was discovered in 1974.

BASE-jumping is a sport involving the use of a parachute to jump from fixed objects. "BASE" is an acronym that stands for the four categories of fixed objects from which one can jump: Building, Antenna (an uninhabited tower such as an aerial mast), Span (a bridge or arch) or Earth (a cliff or other natural formation)

The world's largest baseball bat is located at 800 West Main Street, Louisville, Kentucky at the Louisville Slugger Museum. The bat was built in 1995, resembling the 34-inch (0,87 m) bat used by Babe Ruth, only this one is 120 feet (36.5 m) long and weighs 68,000 pounds (30,844 kg).

Glen Gorbous, a Canadian minor leaguer, who had a three-year stint in the Majors from 1955-1957, still holds the record for the world's longest baseball throw. In 1957, after a running start, the ball left his arm at an estimated 120 mph (193 km/h) and it flew and flew and flew. The baseball covered a total of 445 feet 10 inches (136 m) before hitting the ground and breaking the old record by a whole nine inches (23 cm).

On February 16, at 2:00 P.M. at the 2006 NBA All-Star Jam Session in Houston, Texas, Joseph Odhiambo broke the record setting the new benchmark for dribbling a basketball for the longest time at 26 hours 40 minutes. Three days later he set the record for the world's longest basketball spin, 4 hours and 15 minutes.

In 2002, Justin Phoenix made a shot from 94 feet 5.5 inches (29 m) and it went in, giving Justin Phoenix the record for the world's longest basketball shot.

The world's longest bicycle race is RAAM; Race Across America. (It was called the Great American Bike Race in its first year in 1982.) As routes and distances vary year to year it's hard to determine records, but the fastest race to be completed by a solo rider was 8 days, 9 hours and, 47 minutes by Pete Penseyres in 1986, covering 3,107 miles (5,000 km).

The world's longest dive took almost six hours and reached a measured depth of 35,813 feet (10,916 meters).

On April 28, 1996, Ted St. Martin set a basketball record as he sank an unimaginable 5,221 straight shots from the free throw line.

The longest hockey game in the world was 240 hours and was played on February 12, 2005, in Sherwood Park. Forty players began a 10-day marathon to raise money for Pediatric Cancer Research. Ten days later the record was set.

Roxann Rose holds the record for hula hooping. She currently holds the record for most continuous revolutions of a hula hoop, which she set from April 2 to April 6, 1987, a mind blowing 90 hours of mid-section twisting.

In Pennsylvania on May 29, 1998: David "Cannonball" Smith Sr. is shot out of a cannon. He leaves the cannon at over 70 mph (113 km/h) and soars 185 feet 10 inches (56.54 meters) to land safely and thereby setting the world record for the longest human cannonball flight.

Two lowly teams, the 1995-96 Vancouver Grizzlies and the 1997-98 Denver Nuggets, each losing twenty-three games in a row, hold the record for the longest losing streaks in the NBA.

Daniel Baraniuk, from Gdansk, Poland, spent 196 days, from May 15, 2002 to November 26, 2002, on an 8-foot (2.4 m) pole, with a 1 1/2 x 2 foot (0.46 x 0.61 m) platform, to win the World pole-sitting competition and $23,000 in prize money. He did get a 10-minute break, to come down from his pole every two hours.

On July 9, 2005, Danny Way jumped over the Great Wall of China on his skateboard, becoming the first person to jump the wall without motorized aid.

Suresh Joachim from Mississauga, Canada (of Sri Lankan Tamil ancestry) stood motionless for 21 hours and 30 minutes in Australia breaking the previous record of 20 hours and 10 minutes held by India's Om Prakash Singh. The only movement permitted in this record is involuntary blinking. Suresh Joachim holds at least 30 other world records.

On May 25,th 1997, Suresh Joachim broke the record for the longest time balanced on one foot. Accomplished at the Uihara Maha Devi Park Open Air Stadium in Sri Lanka, Suresh Joachim balanced on one foot for a teetering 76 hours and 40 minutes. During this time, Suresh Joachim did not rest on any object and was not even allowed to rest one leg against the other.

Anthony Thornton spent December 31, 1988 and January 1, 1989, walking backwards around Minneapolis, Minnesota. When he was done walking backwards, Anthony Thornton had covered a record setting 95.4 miles (153.5 kilometres) with an average speed of 3.9 mph (6.4 km/h).

The record for the world's longest yo-yo spin, or better known as "the sleeper", has two categories; fixed axle and transaxle. The world's longest fixed axle sleeper was set by Tim Redmond at the Massachusetts State Championships in Amherst, Massachusetts on March 26, 2006, at 2 minutes and 53.61 seconds. The world's longest transaxle sleeper was also set by Tim Redmond at the Pennsylvania State Yo-Yo Championships on May 28, 2005, at 16 minutes and 17.18 seconds.

Hot air balloons do not fly in the rain because balloon heat can cause water to boil atop the balloon, and boiling water destroys the fabric.

Ashrita Furman from New York City skipped rope 130,000 times in 24 hours.

Fourteen students from Stanford University leapfrogged 996 miles (1,603 km) in May of 1991.

Pigeon racing is a sport in which pigeons are removed to an agreed distance from their home lofts and then released at a predetermined time. The arrival of each bird at its home loft is carefully recorded.

How do you hula hoop with eighty-two different hoops at once? Ask Lori Lynn Lomeli – she did it in 1999.

Did you know that there is such a thing as elephant polo? Elephant polo was first played in India around the turn of the 20th century. The first games were played with a soccer ball, but after finding that the elephants like to smash the balls, the soccer ball was replaced with a standard polo ball. Most of the rules of the games are based on horse polo, but the pitch is 3/4 length (because of the slower speed of the elephants) and there are some necessary additions – for instance, there is a penalty for an elephant to lie down in front of the goal line.

Eddie McDonald once completed thirty-five different yo-yo tricks in a single minute.

Actor Jay Silver Heels, who played the character Tonto in "The Lone Ranger", retired from show business in 1984 and became a harness racing driver.

The defending champion at The Masters Tournament (golf) selects the menu and acts as the host for the "Champions Dinner"," which is held the Tuesday before the tournament. Examples of dinner menus include:
– Tiger Woods, 1998: Cheeseburger, grilled chicken sandwich, French fries, strawberry and vanilla milk shakes, strawberry shortcake.
– Vijay Singh, 2001: Seafood tom kah, chicken panang curry, baked sea scallops with garlic sauce, rack of lamb with yellow kari sauce, baked filet Chilean sea bass with three flavor chili sauce, lychee sorbet.

Polo, though formalized and popularized by the British, was derived from watching natives of Manipur (India) play. In India, the game was not a "rich" game but was played even by commoners who owned a horse.

Competitive pole vaulting began with bamboo poles.

Buzkashi, Kok-boru or Oglak Tartis is a traditional Central Asian team sport played on horseback. The steppes' people were skilled riders who could grab a goat or calf from the ground while riding a horse at full gallop. The goal for a player is to grab the carcass of a headless goat or calf, and then get it clear of the other players and pitch it across a goal line or into a target circle or vat.

Horseball is a game played on horseback where a ball is handled and points are scored by shooting it through a high net. The sport is like a combination of polo, rugby, and basketball.

A hockey puck is made of vulcanized rubber.

In the original versions of water polo, the goaltender stood on the pool deck, ready to dive on any opponent who was about to score.

The youngest winner of the Tour de France was Henri Cornet at the age of twenty in 1904.

NASCAR has by tradition only allowed American-made cars to compete in the race.

The total distance in the Tour de France changes every year.

The first women's boxing match in the U.S. took place in New York City, in 1876.

A linesman is estimated to run about four miles (6.5 km) during a soccer game.

The first time a woman from Iran competed in the Olympics was in 1996.

Manchester United was first known as Newton Heath. They changed their name in 1902.

The penalty kick in soccer was introduced to the game in 1891.

The first bowling pins were so light that sometimes they flew out the window of the bowling club.

If you enjoy both intellectual and physical training, the hybrid of sports chess and boxing may be the thing for you. A chess boxing match between two opponents consists of up to eleven alternating rounds of boxing and chess sessions, starting with a four-minute chess round followed by two minutes of boxing and so on. Between rounds, there is a one-minute pause, during which competitors change their gear.

Judo is the second most-practiced sport worldwide, behind the most-widely practiced sport of soccer.

A practitioner of karate is called a "karateka".

The word karate means empty hand.

"The Karate Kid" started filming on October 14, 1983 and was finished a mere forty-two days later. It was a relatively low-budget production but . It grossed over $100 million at the U.S. box office. "The Karate Kid" was also the highest grossing video rental in 1985.

In sumo wrestling, women are not allowed to enter the ring used by wrestlers, as this is traditionally seen as violating the purity of the dohy (the wrestling ring).

Grasping or holding an opponent's genitals are illegal moves in wrestling.

The game of volleyball was invented in 1895 by William G. Morgan, a teacher at a YMCA in Holyoke, Massachusetts. He combined parts of other sports to create a new game to be played indoors by people who wanted less physical contact than basketball.

Volleyball was first called "mintonette" but it was later changed to volleyball, describing the way players volley the ball back and forth over the net.

If you're afraid of horses and elephants, you can try bicycle polo instead. But you might find this version quite scary, since the bicycles used in the game are not allowed to have brakes.

Titanic was the first ocean liner to have a swimming pool and a gym.

If you have blonde hair that turns greenish from the chlorine found in swimming pools, you can put ketchup on it and it will balance out the pigments.

It is illegal to swim in Central Park.

In 1972, Mark Spitz was the first Olympian to win seven gold medals in one Olympics.

Bossaball is a mix of volleyball, football, gymnastics and capoeira. The court is a combination of inflatables and trampolines, divided by a net. The aim of bossaball is for each team to ground the ball on the opponent's field. It mixes sport with music and any body part can be used.

The trampoline was invented in the early 1930's, thanks to George Nissen. He got the idea by observing trapeze artistes performing tricks when bouncing off the safety net. He made the first modern trampoline in his garage and later reproduced this on a smaller scale.

Haggis hurling is a Scottish sport involving the hurling of a haggis as far as possible for distance and accuracy from atop a platform (usually a whisky barrel). The haggis must be edible (haggis is stuffed sheeps stomach).

If you have the hobby of trying to get from point A to point B as efficiently and quickly as possible, using principally the possibilities of the human body, you are practicing the physical art form Parkour. It is meant to help one overcome obstacles, which can be anything in the surrounding environment.

The acronym NASCAR stands for the National Association of Stock Car Auto Racing.

On October. 15, 1997 the British Thrust SSC became the first jet-powered "automobile" to break the speed of sound (mach 1). The dual engine land jet blasted to an average speed of 766.61 mph (1,234 km/h).

David Letterman is part owner of the Team Rahal auto racing team. The majority owner is Bobby Rahal, the 1986 Indianapolis 500 champion.

The first Wimbledon Championship took place in 1877 and it was watched by almost 200 people. In 1999 it was broadcast to 174 countries, with about one million people watching.

The company Slazenger has supplied every tennis ball for the Championship at Wimbledon since 1902.

Tennis uniforms have changed over the years. Bunny Austin was the first man to wear a pair of shorts on a court at Wimbledon in 1933. Contrarily, Yvon Petra was the last to wear long pants on a court in 1946.

Women's fashions have also caused stirs. Gussie Moran wore a short, lace-trimmed skirt in 1949 and was accused by the AELTC of "bringing vulgarity and sin into tennis".

Table tennis balls aren't really hollow. They are slightly pressurized with a gas.

In China, most children are evaluated for certain inherent talents early on. If they are found to be particularly proficient at something, like gymnastics or table tennis, they receive rigorous training in that area.

Table tennis was banned in the former Soviet Union from 1930 to 1950 because the sport was believed to be harmful to the eyes.

Women surfers date back to the early 1800's.

Racketlon is a cousin of triathlon and decathlon. It combines the four most popular racket sports in the world: table tennis, badminton, squash and tennis.

The world's first alpine skiing chairlift was (and still is) located in Sun Valley. Built by Union Pacific Railroad engineers, it was designed after a banana-boat loading device. The 1936 fee: 25 cents per ride.

Ski bobbing is a winter sport involving a bicycle-type frame attached to skis instead of wheels.

Curling was brought to North America by Scottish immigrants.

The marathon in Berlin is 26 miles (41.8 km), which was apparently was too long for the thirty-three runners who decided to take a shortcut by riding the subway. They obviously forgot the computer chips they were wearing, which automatically record their time every three miles (4.8 km). They were of course disqualified and their times were removed from the scoreboard.

In the 2006 Winter Olympics, half of the U.S. men's and women's curling teams hailed from the small Minnesota town of Bemidji, population 13,000.

Skijoring is a cross between dog sledding and cross-country skiing. A dog pulls a skier, who, depending on the terrain, either skis along or brakes.

An early Hollywood nod to snowboarding was in the James Bond film "A View to a Kill" – the opening sequence featured Roger Moore as Bond eluding attackers with an improvised snowboard.

Today, about 30 percent of snow sport participants are on snowboards.

There are only twelve official bobsleigh tracks in the entire world.

Wok racing is a sport developed by the German TV- host and entertainer Stefan Raab. Modified Chinese woks are used to make timed-runs down an Olympic bobsled track. The World Wok Racing Championships are aired by the German television channel Pro7 as a special edition of Raab's show "TV total".

Fit people tend to sweat more and sooner than unfit people. Their bodies are more efficient at cooling.

When people start training as a result of a New Year's Resolution, 60 percent have quit by Valentine's Day.

Men tend to overestimate their strength while women tend to underestimate their strength.

High-level endurance training (e.g. marathon training) reduces testosterone levels by 15-40 percent.

Acclimation to exercising in the heat can take about 10-14 days. For each two days of not exercising in heat, one day of acclimation is lost.

Men have about eighteen times higher levels of testosterone than women. Men with higher natural testosterone levels gain muscle faster. People who have a harder time gaining muscle have lower testosterone levels.

At the age of twenty-three, Arnold Schwarzenegger was the youngest to win the Mr. Olympia title (the international annual bodybuilding contest).

Schwarzenegger won the Mr. Universe title in 1968 – and every year thereafter until 1975, when he retired. (He won again in 1980).

Wayne Gretzky and his father, Walter, were always close friends. "He never missed a practice, he never missed a game", Wayne Gretzky once recalled. "We never went on holidays because he wanted all the money to be put toward athletics and that kind of stuff. When I was eight years old, I remember my mom, Phyllis, saying, 'I need a new set of curtains', and my dad said, 'hang a couple of sheets up. We gotta get Wayne a new pair of skates'."

Many fans showed up at Gretzky's childhood games with stop-watches – to see how long Gretzky would hold the puck. Former Kings head coach Parker MacDonald once said that "trying to stop Wayne is like throwing a blanket over a ghost".

Like many players, Wayne Gretzky was slightly superstitious. "I don't like my hockey sticks touching other sticks", he once revealed, "and I don't like them crossing one another, and I kind of have them hidden in the corner. And I put baby powder on the ends..."

In the summer of 2001, Manchester United midfielder David Beckham abandoned his trademark Mohawk haircut. Beckham's explanation? He was concerned about children copying the hairstyle and getting into trouble.

Former president Calvin Coolidge's favorite sport was dwarf tossing. Dwarfs wearing special padded clothing are thrown onto mattresses by patrons who compete to throw the dwarf the furthest. (Some sports are more offensive than others.)

Did you know that tug-of-war used to be an official Olympic Games event?

Air hockey was invented in 1972 by Bob Lemieux, an avid ice hockey fan and an engineer at Brunswick Billiards.

Billiards evolved from a lawn game similar to croquet played sometime during the 15th century in Northern Europe.

The term "poolroom" now means a place where billiards is played, but in the 19th century a poolroom was a betting parlor for horse racing. Billiard tables were installed so patrons could pass the time between races. The game of billiards and the poolroom became connected in the public's mind. Today, the two terms are used interchangeably.

Tom Cruise did his own trick billiard shots for the 1986 film, "The Color of Money", except for one in which he had to jump two balls to sink another. Director Martin Scorsese said he wanted to let Cruise learn the shot, but it would have taken two extra days of practice, which would have held up production and cost thousands of dollars. The shot was instead performed by professional billiards player Mike Sigel.

Archery is Bhutan's national sport.

Before the invention of celluloid and other new-age plastics, billiard balls were made out of ivory. Elephants can thank their present existence to the invention of plastic, because billiard balls had to be cut from the dead center of a tusk, the average tusk yielded only three to four balls.

At times, including during the Civil War, billiard results received wider coverage than war news. Players were so renowned that cigarette cards were issued featuring them.

The origins of table football, or "foosball" are unclear, but most historians agree that the first tables probably appeared in Spain, France or Germany in the 1880's or 1890's.

A wooden racket was last used at Wimbledon in 1987.

The Gay Games is a popular sporting and cultural event organized by LGBT athletes, artists, musicians, and others. Originally called the "Gay Olympics", it was started in San Francisco in 1982. The Gay Games is open to all who wish to participate, without regard to sexual orientation. There are no qualifying standards to compete in the Gay Games. It brings people together from all over the world, many from countries where homosexuality remains illegal and hidden.

The Kentucky Derby trophy is made of 56 ounces (1.6 kg) of 14 and 18 carat gold, and is two feet (0.61 m) tall.

The horseshoe atop the Kentucky Derby was originally pointing down, and was turned 180 degrees to point upward in 1924.

The Colosseum arena could hold up to 50,000 people at once. Ancient Rome's biggest arena, The Circus Maximus, had seating for 250,000 Romans.

Thirty-nine-year-old Greg Billingham decided to "run" the 26.2 mile (42.2 km) London Marathon at an ultra-slow pace of three miles (4.8 km) every tenth hour, to raise money for the charity "Children with Leukaemia". He said he ran in slow motion because people who become ill often find their lives slowed down. "Slow motion" marathon runner Greg Billingham finished one week after the event started.

Each year, as New York gets hot and sticky, the annual Manhattan Island Marathon Swim offers a way to cool down for all those crazy enough to attempt a 28.5-mile (45.9 km) sprint through the waters of the Hudson River.

Bruce Lee studied with different masters of classical martial arts forms, but became dissatisfied with them. He took the best of all of those arts, combined his own ideas and created his own style called "Jun Fan Gung Fu", a modification of Wing Chun combined with western boxing and fencing. This would later lead to his own refined school of the martial arts: "Jeet Kune Do".

Bruce Lee was, besides a martial art master, also an accomplished dancer and a Hong Kong Cha Cha champion.

Muhammad Ali is a vegetarian.

One cylinder of the eight cylinders of a Top Fuel dragster or a Funny Car produces 750 horsepower, equaling the entire horsepower output of a NASCAR engine.

Steve McQueen patented a specific bucket seat in a racecar.

In 1988, female athlete Jackie Joyner-Kersee was named "The Sporting News Man of the Year". She is the only woman to ever have been selected for that honor.

A baseball player can earn a golden sombrero by striking out four times in a game. A player who strikes out five times in a game earns Olympic rings or a platinum sombrero, and a player who strikes out six times earns a horn or titanium sombrero. The last player to earn one of these dubious distinctions was Alex Rios of the Toronto Blue Jays who earned a platinum sombrero in a game on July 29, 2006.

The most ever paid for a baseball card was a rare 1909 card of Honus Wagner that was sold on eBay in 2000 for $1.265 million in the year 2000.

Moses Malone was the first basketball player to go directly from high school to play for a professional basketball team.

Shirt swapping was once officially prohibited at the World Cup in 1986 because FIFA did not want players to "bare their chests" on the field.

The most common surname of World Cup players is Gonzalez or Gonzales.

The Romanian team in the 1930 World Cup were selected by their King. The "'soccer-crazy'" King Carol II of Romania personally selected the team, and then asked the employers to grant each player a three-month leave with full pay.

The U.S. trainer had to be carried off the field unconscious during the 1930 World Cup semi-final against Argentina after he ran to the pitch to attend an injured player, dropped his medicine box, and broke a bottle of chloroform. When he tried to pick up the broken bottle, he took in the fumes and fell to the ground immediately. The injured player recovered without any treatment.

To prevent the Nazis from confiscating the golden Jules Rimet World Cup Trophy, Dr. Ottorino Barassi, an Italian sports official, smuggled the trophy from the bank in Rome, and hid it under his bed for most of the war before the 1950 World Cup.

India withdrew from the 1950 World Cup finals, as they were not allowed to play in bare feet. They have not had the chance to compete again since then.

USA beat England 1-0 in the 1950 World Cup finals, though some British newspapers reported the result as USA 1, England 10 as the editor believed that the reporter had made a typing mistake. Before the match, both sides believed that it would be an easy win for England, and double-digit goals were expected. This match is now considered by many people as the greatest upset in World Cup history.

After playing with Spain in a World Cup qualifying match in 1993, the Albanian coach asked his players not to swap shirts, as they had no money to make new shirts, and he wanted to save the shirts for the next match. As for not having a full complement of shirts, the financially beleaguered Albanian team also had to pay their own way to get to the stadium.

Ronaldo changed his hairstyle after Brazil beat England in the 2002 World Cup quarter finals to look more different from his teammate Roberto Carlos. He wanted to have a new look because his son Ronald had wrongly recognized Roberto Carlos as Ronaldo – their toddler son kissed the TV screen shouting "daddy" when Roberto Carlos appeared on TV during the quarter final match.

Until 1967, it wasn't illegal for Olympic athletes to use drugs to enhance their performance during competition.

Boris Becker had trials with German soccer team Bayern Munich before becoming a tennis champion.

The great French fighter Georges Carpentier started his career as a Flyweight and ended his career as a heavyweight. He fought in every divison boxing has to offer!

Muhammad Ali was known for fighting with his hands held low, even down by his waist. But Aaron Brown "The Dixie Kid" was the first man to fight in this style.

The last two fighters to participate in a fight to death were Sam Langford and Jim Savage who fought in 1923 at the Plaza de Toros in Mexico City.

Elvis Presley's favorite sport was football.

The notorious swimmer Michael Phelps is the only swimmer in history to set five individual world records in one international meet and the first male swimmer to break two world records in separate events in the same day. No wonder the city of Baltimore, Phelps' birthplace, decided to rename a street in his honor: Michael Phelps Way.

Jacques Plante was the first hockey goaltender to regularly wear a goalie mask. He did so after being struck in the face by a puck.

A puck is also used in underwater hockey. While it essentially looks the same as an ice hockey puck, the underwater hockey puck differs in that it has a metal core weighing approximately 3 pounds (1.5 kg) within a plastic coating.

Lance Armstrong won the Iron Kids Triathlon at age thirteen, and became a professional triathlete when he was sixteen. Since then, he has won the Tour de France seven times. Lance's nickname is Tour de Lance because of this record.

Lance Armstrong has appeared in the movies "Dodgeball" and "You, Me, and Dupree" as himself.

Lance Armstrong's children were conceived with sperm that Armstrong banked before he began chemotherapy for testicular cancer.

O.J. Simpson was the first pro football player to grace the cover of Rolling Stone magazine in September 1977. He was also the first professional athlete to host the sketch comedy show "Saturday Night Live" on February 25, 1978.

O.J. Simpson was the only former host not invited to attend the "Saturday Night Live" 25th Anniversary Special.

Joe DiMaggio was briefly married to Marilyn Monroe.

Babe Ruth's other nicknames included "The Bambino" and "The Sultan of Swat".

The Red Sox did not win a World Series for 85 years after selling Babe Ruth to the Yankees, a drought known as the "Curse of the Bambino". However, the Sox broke the 'curse' by winning the World Series in 2004.

Dennis Rodman's nicknames include "Dennis the Menace", "Rodzilla", "D-Rod", "Rod the Bod", and "Worm", the latter given to him by his mother for wriggling around while playing pinball.

The creator of the NIKE Swoosh symbol was paid only $35 for the design.

Dennis Rodman has been seen several times in the running of the bulls at the San Fermín festival in Pamplona, Spain.

The skateboarder Tony Hawk was in one of "Weird Al Yankovic's" music videos, wearing a long wig.

Tony Hawk has been a professional skateboarder since he was fifteen and he's the first skateboarder to do "the 900" skateboarding trick. This requires two and half turns in the air on a vert ramp. He is the first and only skateboarder to date who has successfully done this trick. He has done "the 900" over fifteen times.

The professional tennis player Roger Federer is the first living Swiss to be pictured on a postage stamp. The stamp was issued in April 2007, and shows Federer with the Wimbledon trophy. Switzerland does not normally depict persons on its stamps, except for historical figures.

Sports such as gymnastics, figure skating, dancing and synchronized swimming have a higher percentage of athletes with eating disorders, than sports such as basketball, skiing and volleyball.

The National Baseball Hall of Fame & Museum is located in Cooperstown, New York. It was created in 1935 to celebrate baseball's 100th anniversary.

The world-famous Harlem Globetrotters got their start in Chicago as the "Savoy Big 5". They played their first game at Chicago's Savoy Ballroom in 1926 and became the Harlem Globetrotters in 1927.

The Chicago Bears were the first football team in the U.S. to practice daily.

During the height of his career, the former number one world tennis player Peter "Pete" Sampras, claimed to sleep twelve hours every night.

When R&B/pop singer Usher was younger, he studied karate under professional wrestler Ernest Miller for four years.

Britney Spears was an accomplished gymnast, attending gymnastics classes until age nine and competing in state-level competitions.

The rap artist 50 Cent competed in the Junior Olympics as an amateur boxer. He aspired to fight in the Golden Gloves boxing tournament but was too young to compete.

The owner of the Chicago Cubs, Bill Veeck, used to have midgets as food vendors at the club's home ground because he said that it meant that the paying public didn't have to have their view of the game spoiled!

In March 1976, the groundskeeper at the Angel Stadium in Anaheim was inspecting the home turf when something caught his attention. Growing there unhindered was a marijuana plant. It turns out that there had recently been a concert at the stadium by musical band 'The Who' and a visitor was suspected of having planted it.

Madden NFL '06 is said to have a curse, because all the players who have been featured on the cover of this game have suffered some kind of injury or career setback during the same season they appeared on the cover. This video game is extremely popular and it is an honor to be featured on the cover.

"The Sports Illustrated cover curse", basically means that you are jinxed if you are on the cover of Sports Illustrated. Many people do not really buy into this, but for some, they claim that the curse has ruined their life.

"The Curse of Billy Penn", This curse originated in 1987 in the town of Philadelphia. Prior to 1987 the town had experienced much sporting success in all major sports including football, baseball, ice hockey, and basketball. Since 1987 Philadelphia has yet to win a championship game in any of these sports. There was this hometown tradition that existed prior to 1987. No building in Philadelphia was taller than the statue of William Penn – founder of Philadelphia. But in March of 1987 a skyscraper was built, known as "One Liberty Place", which towered over the Penn statue. Since then no Philadelphia team has won a championship in their respective league.

Michael Jordan played basketball for Laney High School in Wilmington, North Carolina. Ironically, Jordan was cut from the varsity team as a sophomore. Instead of giving up after failing to make the team, Jordan used it to spur himself to greater achievements, practicing hour after hour on the court. "Whenever I was working out and got tired and figured I ought to stop, I'd close my eyes and see that list in the locker room without my name on it," Jordan said, "and that usually got me going again." He eventually made the team and led it to the state championship.

Tony Hawk played the role of a skateboarder in "Police Academy 4: Citizens on Patrol".

Mike Tyson's 48,000 square-foot mansion in Farmington, Connecticut, was purchased on September 21, 2003, by 50 Cent for $4.1 million.

Mike Tyson admitted he was interested in breaking into the porn industry after allegedly being approached by representatives of porn superstar Jenna Jameson to appear in a movie with her. He seriously considered the offer because he was desperate for cash after blowing millions. However he snubbed the offer back in September 2005.

Mike Tyson was banned for one year and fined $3,000,000 after biting off a piece of Evander Holyfield's ear.

In the animated movie "Cars", Mario Andretti does the voice of a 1967 Ford Fairlane, which is the car in which he won the Daytona 500.

The youngest player ever to play for England is Wayne Rooney, at the age of seventeen years and 111 days. Seven months later, he became England's youngest-ever goal scorer when he netted against Macedonia in September 2003, and at one stage (in June 2004) he held the record for being the youngest goal scorer in the European Championship finals, at the age of eighteen years and 236 days.

The world's first six-figure soccer crowd - 110,802 - assembled inside London's old Crystal Palace ground for the 1901 FA Cup final between Tottenham Hotspur and Sheffield United.

The biggest crowd ever to watch a football match is 199,850, at the giant Macarena Stadium in Rio de Janeiro for the Brazil vs. Uruguay World Cup final in July 1950.

The quickest sending off in Football League history is zero seconds: Walter Boyd (Swansea City) being the culprit at Darlington on 23 November 1999 (as a substitute).

Ramon Moya, manager of CF Hospitalet, lost control of himself when his side scored a dramatic last-minute winner in a Spanish Second Division match in 1998 against CF Figueres and was sent off - for kissing a linesman!

Three players from the Argentinian club Estudiantes were imprisoned by the country's president after an unruly World Club Championship clash with AC Milan.

Spanish heart-throb singer Julio Iglesias was once registered as a goalkeeper with Real Madrid.

Until 1912 a goalkeeper was allowed to use his hands anywhere on the field of play.

Pelé (Brazil) netted 1,283 goals in twenty-two years between 1956 and 1978.

Extrovert Paraguayan goalkeeper Josée Luis Chilavert scored a hat-trick in a league game for Velez Sarsfield against Ferro Carrilk Oeste in November 1999. He ended his career with over fifty senior goals to his credit - a record for a goalkeeper anywhere in the world.

In 1988/89, the longest result ever recorded in world soccer, in terms of letters and figures, came in a third-round Welsh Cup tie which the home side, Kidderminster Harriers, won 3-0 against Llanfairpwllgwyngyllgogerychwyrndrobwllllantysiliogogogoch.

The footballer with the longest name ever to appear in a League game is Arthur Griffith Stanley Sackville Redvers Trevor Boscawen Trevis who lined up at centre half for West Bromwich Albion against Liverpool in April 1934, his only senior outing for the Midlands club.

In the early 1960's, players of the unsuccessful Paelem club from Belgium vowed not to shave until they won a game - it took them thirty-five matches before they used a razor!

In the early 1960's Tore Hansen of Fredrikstad in Norway, aged fifteen, set a world record of keeping the ball in the air for 2 hours and 21 minutes. Watched by four referees, he headed, kicked and bounced the ball off his body no less than 16,098 times without it ever touching the ground.

After a goal had been controversially disallowed during a league match in Livramento, Brazil, in the early 1960's, an irate fan raced onto the pitch and knocked out the referee. Another supporter then came onto the field of play and stabbed the first fan, only for a third spectator to come forward to shoot the second with a revolver.

In the summer of 1949, a soccer player from Hungary was transferred to an Italian club for a doughnut-making machine!

Notts County's Andy Legg entered the Guiness Book of Records in August 1994 by recording the longest ever throw-in in first-class football by hurling the ball 134.5 feet (41 m).

The South African League game between Jomo Cosmos and Moroka Swallows in 1998 came to an abrupt end when several players were hit by a bolt of lightning.

The number 10 shirt worn by Brazilian superstar Pelé in the 1970 World Cup finals was sold at Christie's auction room in London on 27 March 2002 for 157,750 pounds.

1 in 8,606: One often-repeated estimate as to the odds of making a hole-in-one. That averages out to one in every 478 rounds.

49: Holes-in one made by golf pro Mancil Davis, who had more in his career than any other pro.

7: The world record for the number of golf balls balanced on top of each other.

Despite Tiger Woods, black golfers make up only 3,3 percent of all golfers – professional and amateur – a figure unchanged over the last decade.

Al Capone always carried a gun in his bag when he went golfing. While playing at Burnham Woods Golf Course near Chicago, the gun went off accidentally, shooting Scarface's foott.

In 1994, a farmer in Germany sued the owner of a golf course. The farmer had been complaining that errant golfers had been hooking balls into his field for years. After the mysterious death of one cow, a veterinarian discovered a golf ball lodged in its throat. Further investigation revealed that thirty of his cows had developed the habit of swallowing golf balls and that they collectively had a total of 2,000 balls lodged in their stomachs.

According to the golf industry, a golf course needs about 40,000 paid rounds of golf each year to make a profit.

Uganda's Jinja Golf Course has a couple of interesting additions to the usual golf rules that may not be encountered anywhere else in the world. For instance, if a ball lands near a crocodile and it's deemed unsafe to play it, you may drop another ball. Also, if your ball lands in a hippopotamus footprint, you may lift and drop the ball without incurring penalty.

"If your ball lands within a club length of a rattlesnake, you are allowed to move your ball", states a sign of local rules at the Glen canyon golf course in Arizona.

Rugby balls have always been oval. The boys at Rugby School used footballs made from inflated pigs bladders, which are themselves oval in shape.

In 1831, Squire George Osbaldeston rode 200 miles (321.9 km) in 10 hours, with an unlimited amount of horses. His speed/distance record still stands.

Kincsem, a Hungarian mare, was unbeaten in fifty-four races (1877-1880) and holds the world's record for best win-lose percentage.

The owners of the speedstar Alsab, made one of the finest deals in history. They bought the horse for $700 and then earned $350,015 during its whole career.

Rubio, a retired racehorse who had been pulling a farm plow for three years, won the 1908 Grand National Steeplechase in England. With 66-1 odds against him, Rubio netted his owner, Major F. Douglas-Pennant, a prize sum of $12,000.

The Formula 1 world championship was started in 1950. Italy's Giuseppe Farina won the first race (the British GP) and the first world championship.

In 1896, British carpenter Brian Gamlin, arranged the numbers on the dartboard as we see them today.

In ancient Japan, public contests were held to see who in a town could fart the loudest and longest. Winners were awarded many prizes and received great recognition.

At 120 miles per hour (193 km/h), a Formula 1 car generates so much downforce that it can drive upside down on the roof of a tunnel.

Racecar driver Lee Petty once left a pitstop and did a full lap at NASCAR with a pit crew member still on the hood.

The world's biggest bowling alley has 106 lanes and is located in Las Vegas at the Showboat hotel.

Three consecutive strikes in bowling is called a "turkey".

www.nicotext.com